N.C. Wyeth

KATE F. JENNINGS

**CHARTWELL
BOOKS, INC.**

Published by
BOOK SALES, INC.
114 Northfield Avenue
Raritan Center
Edison, N.J. 08818

Produced by
Brompton Books Corp.
15 Sherwood Place
Greenwich, CT 06830

ISBN 0-7858-0219-3

Printed in China

LIST OF PLATES

N. C. WYETH

1882-1945

Newell Convers Wyeth, one of America's finest illustrators and the patriarch of an enduring artistic dynasty, was born on October 22, 1882, in the rural township of Needham, Massachusetts. His father was Andrew Newell Wyeth II, a farmer of solid New England stock whose ancestors had first landed at Cambridge, Massachusetts, from England in 1645. His mother, Henriette Zirngiebel, was French Swiss. The chores and activities of a farming household formed the structure of Wyeth's boyhood, instilling in him an abiding respect for nature, and a lifelong affection for animals of many species. He enjoyed the strenuous physical labor required to prepare the fields, to plant, and to harvest their crops; these routine tasks gave him a deep understanding of the human form in motion. The early years that he spent plowing, scything and baling hay, milking cows, tending the livestock with a team of horses, and confronting the elements, were a primary source of subjects in his paintings, posters, and murals.

To his father's chagrin and consternation, N.C. Wyeth was not an avid student, preferring to spend his free moments sketching. Fortunately for Wyeth, his mother encouraged his predilection for drawing. She persuaded her husband to allow Wyeth to attend the Mechanic Arts School in Boston, where he learned drafting and graduated in 1899, moving on to the Massachusetts Normal Arts School and the Eric Pape School

of Art in Boston. Following this, Wyeth continued his studies with a book illustrator, Charles Reed. When a friend and fellow artist, Clifford Ashley, returned home from Wilmington, Delaware, in the summer of 1902, he encouraged Wyeth to join him at the Howard Pyle School there. Tuition was free but students were accepted on a trial basis; hard work and artistic ability were essential for full acceptance. Wyeth arrived in Wilmington on his twentieth birthday and within four months was a full-fledged associate.

His first sale of his work was to the *Saturday Evening Post* for a painting of a bucking bronco and cowboy. It appeared on their cover on February 21, 1903 and paid fifty dollars. A month later *Success* magazine used Wyeth's canvas of two railroad surveyors perched precariously atop a mountain ravine. The dramatic tension of the pose and central focus of the image's pictorial elements were keynotes of Wyeth's style.

His education under Howard Pyle was a fertile and productive period of his life. In the summertime the school moved to the neighboring countryside of Chadds Ford, Pennsylvania, where classes were held within the lofts of a vacant grist mill. This spacious and romantic setting was ideal for encouraging the young artists. Pyle had taught classes at the Drexel Institute in Philadelphia and was a successful and popular illustrator. He tempered and distilled the forceful enthusiasms of his pupil, honing his technique not only to suit the requirements

of magazine illustration, but also to elucidate certain painterly standards and to satisfy the artist's personal intentions. The group of artists was close-knit, ambitious, and talented, and their work was readily in demand in New York. During one month in the fall of 1905, Pyle and his students were represented in such magazines as *Outing, Metropolitan, Scribner's,* and *Harper's.*

Pyle did not limit his program of instruction to repetitive classroom study. When a fire swept the city of Baltimore in February of 1904, he quickly contacted *Collier's Magazine* and arranged a paid assignment for his protégés, whose sketches would report on the event as it unfolded. They boarded a train posthaste to the scene. Here Wyeth learned the value of firsthand experience to convey a sense of immediacy, drama, and compassion in his illustrations and paintings.

In May of 1904, Charles Scribner and Sons gave Wyeth his first book to illustrate, *Boys of St. Timothy's* by Arthur Stanwood Pier, and the course of his career was shaped by the success of this project. After graduating from the Howard Pyle School, he planned an excursion out West sponsored by the *Saturday Evening Post* and *Scribner's Magazine,* who were interested in a documentary story complete with drawings and full-color canvases of his expedition and the characters he encountered.

On September 24, 1904, Wyeth embarked on the tedious, fifty-four-hour train ride to Denver, where he stayed with the family of a fellow student from Wilmington, Alan True. In addition to their hospitality, the Trues gave him permits to visit local Native American reservations. From Denver he moved on to Deer Trail, Colorado, where he met up with a sheepherder who took him to his destination – Elroy Gill's ranch. The first narrative tale of Wyeth's adventures was 'A Day with the Round-Up' published in March 1906. His concise declarative sentences suit the taciturn nature of the cowboys and cattle ranchers who were his companions, and they match the spare, austere beauty of the surrounding desert and Rocky Mountains.

Wyeth spent one day herding 300 head of cattle through Rattlesnake Gulch and though the conditions were often rough, dangerous, and physically demanding, and the hours long, the artist thrived. He conducted a fair bit of trading and bargaining to accumulate a collection of costumes and artifacts for his illustrations. Any spare moments that he had were used for sketching

the cow-punchers, the broncos, and the vast, mountainous expanse.

After a month or so, he took a stagecoach to Muddy Springs, Arizona. Here he lost his hard-earned cash, amounting to between $350 and $400, when a band of Mexicans raided a government post. He got a job as a mail carrier between Muddy Springs and Fort Defiance, Arizona, riding the eighty-five mile distance every three days or so. In one month he saved enough for his passage back East. He was eager to return to the familiar landscape of Wilmington and its environs, and to his cherished friends.

Wyeth spent New Year's Eve of 1904 with Carolyn Bockius, who was soon to become his fiancée, and he felt unusually positive about his prospects for the future. He continued with his Western illustrations, portraying Kit Carson and Cree warriors in pictures for the *Saturday Evening Post* and Eskimos for *Harper's Monthly.* He and his three brothers, Ed, Nat, and Stimson, took one of their annual walking trips in the hills of Vermont. The strong bonds among the Wyeth sons were reaffirmed on these yearly retreats when they hunted, fished, and camped out together in northern New England.

In late February 1906, N.C. Wyeth returned to the West, this time on behalf of *Outing Magazine,* which required illustrations for a story on mining engineering. He took a job stoking the fires on a work train, traveled to railroad construction camps, and picked up all kinds of Native American curios at local stops. These included squaw dresses, a beaded vest, a silver belt, tom-toms, buckskin leggings, and a Mexican sombrero – costumes to be saved for models back home.

After his return he made preparations for his wedding to Carolyn Bockius, whom he married on April 16, 1906, and the furnishing of their first house, a rental in Wilmington. He painted a variety of Native American canvases that were published as prints and offered in a series called 'Solitude' to readers of *Outing.* He grew distant from Howard Pyle, in part because of his former teacher's demands on his time; Pyle had taken a position as an art editor and tried to bolster his own magazine assignments with assurances of additional work by Wyeth.

As early as 1907, Wyeth had begun to feel frustrated with the artistic limitations of his magazine work and for years to come he would chafe under the yoke of these commissions. He yearned to paint the countryside and

independent, selective subjects that did not require the props, melodrama, and contrived pictorial relationships necessary to suit commercial ends.

Fortunately, *Scribner's Magazine* presented more congenial work to him at this time in the form of a poem, 'Back to the Farm' by Martha Bianchi. His paintings to accompany these stanzas were of farmers and their children in the fields – scything, mowing, and plowing with teams of horses – activities he could observe firsthand in the Chadds Ford region. N.C. and Carolyn Wyeth rented a 45-acre farm in Chadds Ford in the fall of 1907. On October 22, 1907, their first daughter Henriette was born on her father's twenty-fifth birthday.

Wyeth had a low opinion of artists who felt compelled to travel to Europe in search of more interesting themes and continental flourishes. The artists and writers he most admired and respected were impressed by content rather than stylistic decoration. One of these was Winslow Homer. Wyeth's second Western story 'A Sheepherder of the Southwest,' appeared in *Scribner's* January 1909 issue, chronicling the arduous, solitary existence of a Mexican shepherd. In addition to plentiful requests for Western and Native American pictures, in 1910 Wyeth was also entrusted with his first story by Arthur Conan Doyle, a saga of sailing warriors.

In the summer of 1910, Wyeth traveled to the fashionable resort in Warm Springs, Virginia, to research families and vistas of the Southern Confederacy for Mary Johnston's book about the Civil War called *The Long Roll*. He was profoundly affected by the tragic consequences the war inflicted on the local citizens and their homeland. In his paintings he was determined to emphasize the suffering these people endured rather than the glories and superficial splendor of war.

The year of 1911 was an unusually eventful and prosperous one for Wyeth. In March he accepted Scribner's offer to illustrate Robert Louis Stevenson's classic book *Treasure Island*. With the proceeds from the contract he was able to purchase his own 18-acre farm in Chadds Ford for $2000 and put down $3600 as a half-payment for the construction of his house and studio. He also received his first mural commission to produce a series of four life-size Native American pictures for the dining room of the Hotel Utica in Utica, New York. He was especially pleased with this assignment since the hotel's developer, Delos Johnson, had used Frederic Remington and Maxfield Parrish, artists

Wyeth respected, for other projects. In addition to the *Treasure Island* illustrations and Hotel Utica canvases, Wyeth completed an illustrated story for *Scribner's Magazine,* a *Century Magazine* story, a painting for the Forbes Company, and one privately commissioned by a Connecticut sportsman. He thrived on the pressure. 'It's no use talking; it's great to be rushed once in a while.' In the summertime he and Carolyn took the children to Beach Haven on the New Jersey shore for a respite from the heat and the demands of his commercial work.

On October 24, 1911, Wyeth's first son, Nathaniel Convers Wyeth, was born. Wyeth was always a proud father, buoyed and inspired by the companionship of his children.

Treasure Island was a popular success for Scribner's. Wyeth was highly regarded for his unique facility for creating riveting narrative illustrations in an expedient manner for their classic books and stories. He followed *Treasure Island* with the book *Pike Country Ballads,* magazine illustrations for Civil War stories, *The Story of Christ,* and a series of Finnish legends. In 1913, Scribner's offered him a second novel by Robert Louis Stevenson, *Kidnapped.* His uncanny ability to identify with his characters and his willingness to become absorbed with their exploits lent his paintings their emotional force and perception, in addition to the technical finesse they displayed.

After World War I broke out in Europe, Wyeth was offered a substantial sum by several magazines to join their correspondents and illustrate significant events as they unfolded, but he declined all offers. He did contribute to the war effort by painting a large mural of Neptune to be used as a poster for the Department of the Navy. He also did several paintings of the troops for the *Red Cross Magazine* and sent work to exhibitions in St. Louis and to the Panama Pacific Exposition. In 1918 he furnished a 92-foot canvas of American soldiers called *Over the Top,* for the New York Treasury Building. He was offered the rank of first lieutenant for his work but refused it.

Right
THE PAY STAGE, 1909
Scribner's Magazine, August 1910
Oil on canvas, 38 × 26½ inches (92 × 68 cm)
Collection of First Interstate Bank of Arizona, N.A.,
Phoenix, AZ

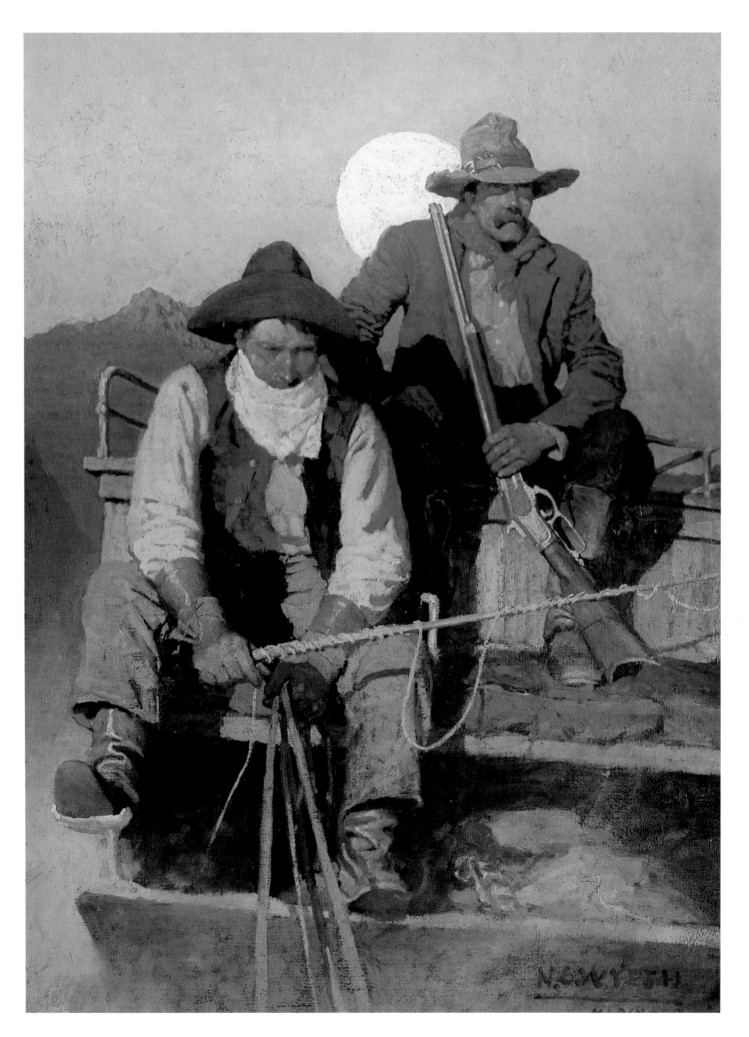

7

Wyeth's primary concerns during the wartime era were his continuing series of book illustrations, a variety of private commissions, and the care and nurturing of his growing family. His third daughter, Ann, was born on March 15, 1915, and his second son, Andrew, was born on July 12, 1917, the 100th anniversary of Henry David Thoreau's birth. Among the novels Wyeth illustrated at this time were Mark Twain's *The Mysterious Stranger,* Robert Louis Stevenson's *Black Arrow,* the autobiography of Buffalo Bill Cody, *Robin Hood* by Paul Creswick, *The Boy's King Arthur* edited by Sidney Lanier, and *The Mysterious Island* by Jules Verne. In 1915 he painted a mural with a marine theme of mermaids and sea dragons for the underground café at the Hotel Traymore in Atlantic City, New Jersey. The hotel was demolished in the 1950s, and unfortunately it is unknown whether the mural was removed and saved. Even with his prodigious output of canvases, drawings, and decorations, Wyeth was besieged with requests for his work and turned away many assignments. He wrote in April 1916: 'There has been so much work offered to me that it has been a constant problem what to take and what to leave.'

Wyeth's prolific production of illustrations continued after the war and into the 1920s, with increasing requests for public murals, memorials, and decorative panels. In 1918 a New York advertising agency tried to lure him into an exclusive contract for $20,000 per year that would have required only a limited number of assignments, but he bridled at the suggestion of restricting his creative opportunities. Instead, he directed his energies and enthusiasm to a variety of historical canvases and heroic tales. He traveled to the Adirondack Mountains to research his canvases for *The Last of the Mohicans.* For these wilderness and Native American paintings, he called upon his own canoeing experiences on the Charles and Delaware rivers. He was also at work on canvases for *The Courtship of Miles Standish, Robinson Crusoe,* and *Westward Ho!* By this time Wyeth had financial arrangements with several of his publishers, who paid royalties to him as a percentage of the number of books sold.

Wyeth's children were beginning to reveal their own artistic sensibilities, particularly Henriette, his eldest daughter. She studied with her father in his studio and he marveled at her instinctive grasp of the intricacies of perspective. Henriette enrolled in the Pennsylvania Academy of Fine Arts in 1923, while Andrew was already revealing a precocious talent in his drawings and canvases.

In the summer of 1921, Wyeth took his family back to his hometown of Needham, Massachusetts, for a year. He had longed to be closer to his parents, his brothers, and the New England region for several years, and to acquaint his children with the community there. Although he would later return to their home in Chadds Ford, he was busy with several Boston murals throughout his stay. For the Federal Reserve Bank in Boston he painted two 10- by 13-foot panels, one of Alexander Hamilton and George Washington, the second of Abraham Lincoln and Salmon Chase.

The family moved back to Pennsylvania in 1923 and Wyeth began a variety of new and challenging projects. He worked on a series of religious paintings for a book about the parables of Christ. Wyeth was a deeply spiritual man and his work on these canvases expresses a certain emotional transport and awe that illuminates the biblical text.

In his later years, he spent more time working on landscape paintings and public murals than his commercial illustrations for publishers. He produced delightful, entertaining canvases for the Houghton Mifflin Company's anthology of children's literature. He also illustrated James Fenimore Cooper's *The Deerslayer* and the cover for the Christmas issue of *The Country Gentleman* featuring Old Kris. Some of the interesting paintings he was commissioned to furnish for clients as diverse as the Hotel Roosevelt in New York and the Metropolitan Life Insurance Company included a triptych called *Half-Moon in the Hudson* and five murals of Pilgrim scenes. He painted murals for schools as well, such as *The Giant,* but was happiest painting the landscapes around him in Chadds Ford and in Port Clyde. He did several memorable works that were exhibited at the MacBeth Gallery in New York and later at Doll and Richards in Boston. He was aware of the talents of his son Andrew, and that he had begun a dynasty of artistry. The conscientious application of observation and technique to painterly goals would continue in the generations that followed him. Wyeth was tragically struck down by a train, in 1945, along with one of his grandsons. Nevertheless, in the legacy of his own work, and in the masterpieces of Andrew and Andrew's son, James, the gifts of N.C. Wyeth live on today.

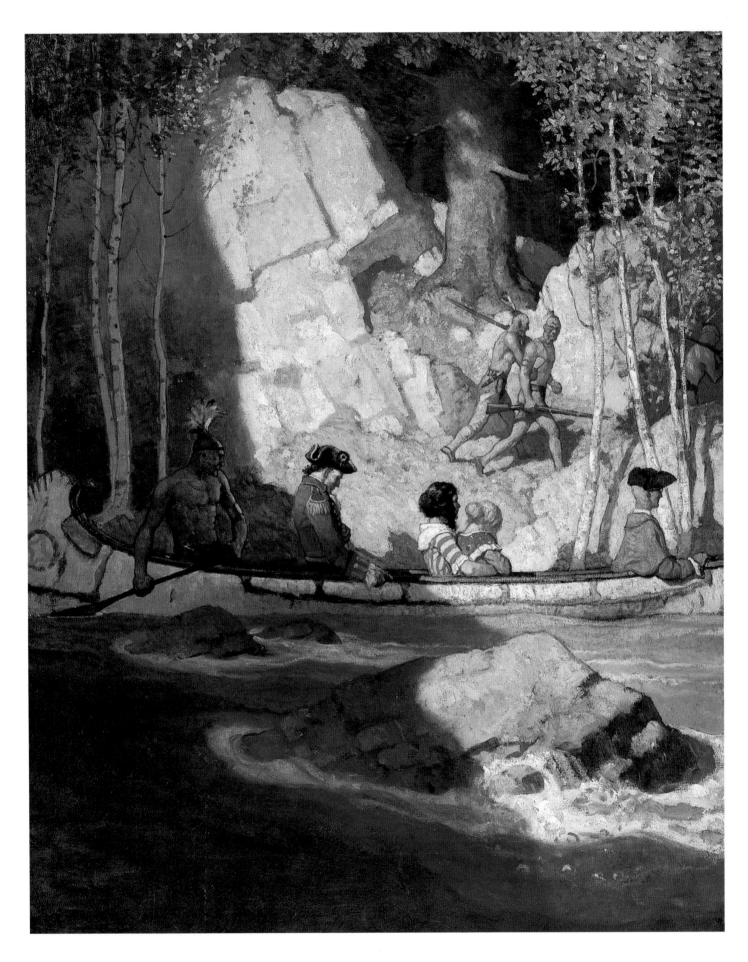

THE CAPTIVES, 1919
The Last of the Mohicans by James Fenimore Cooper
Charles Scribner's Sons, 1919
Private Collection
Photograph by Peter Ralston

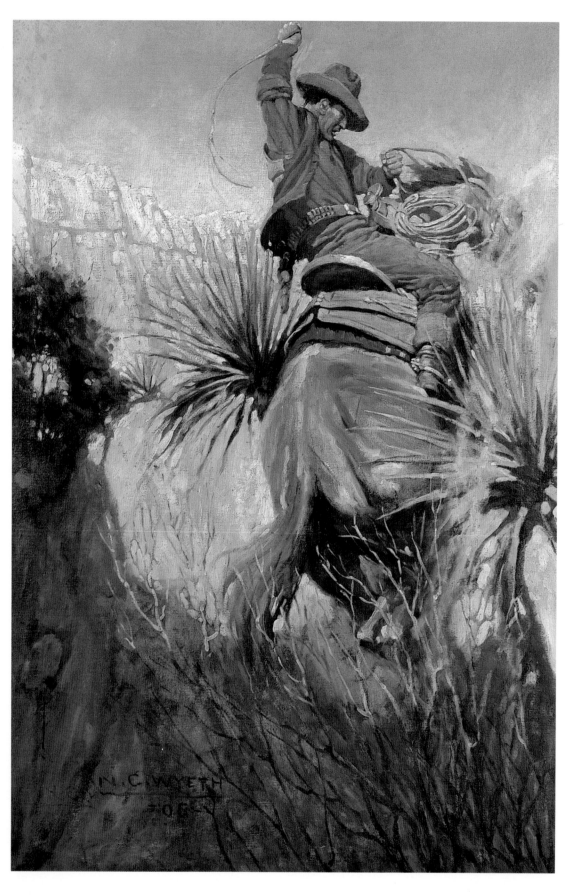

Above
I Saw His Horse Jump Back Dodgin' a Rattlesnake or Somethin', 1905
'Arizona Nights' by Stewart Edward White
McClure's Magazine, April 1906
Oil on canvas, 36 × 23¾ inches (92 × 61 cm)
Collection of First Interstate Bank of Arizona, N.A., Phoenix, AZ

Right
The Admirable Outlaw (My English Friend Thought It Was a Hold-Up), 1906
'The Admirable Outlaw' by M'Cready Sykes
Scribner's Magazine, November 1906
Oil on canvas, 38 × 23⅝ inches (93 × 60 cm)
Courtesy of the National Cowboy Hall of Fame and Western Heritage Center, Oklahoma, OK

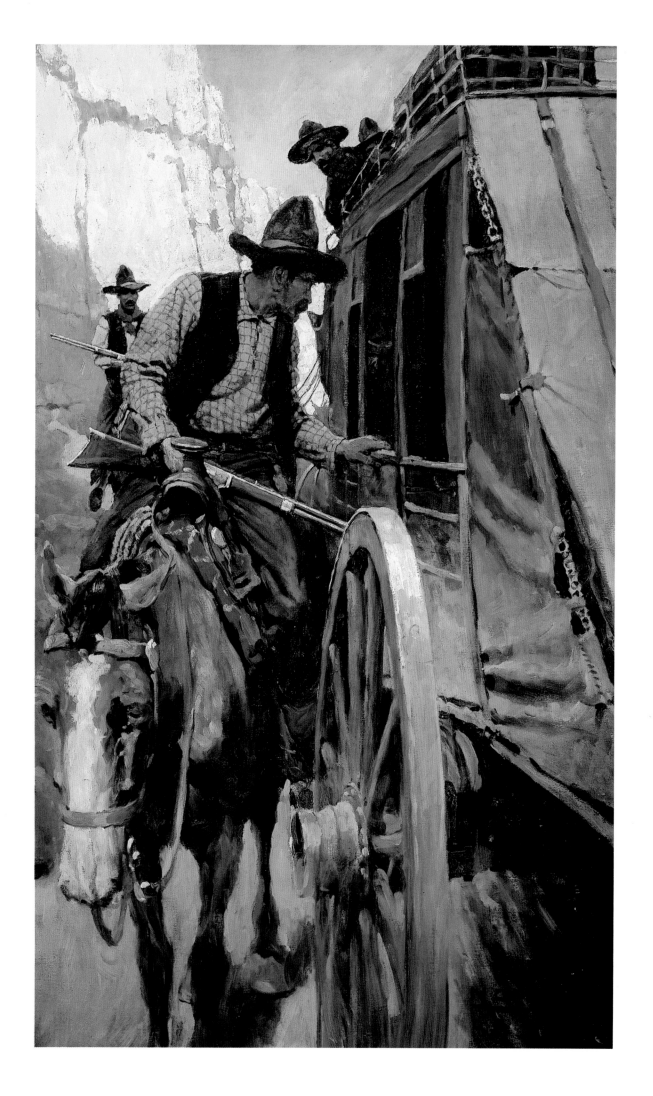

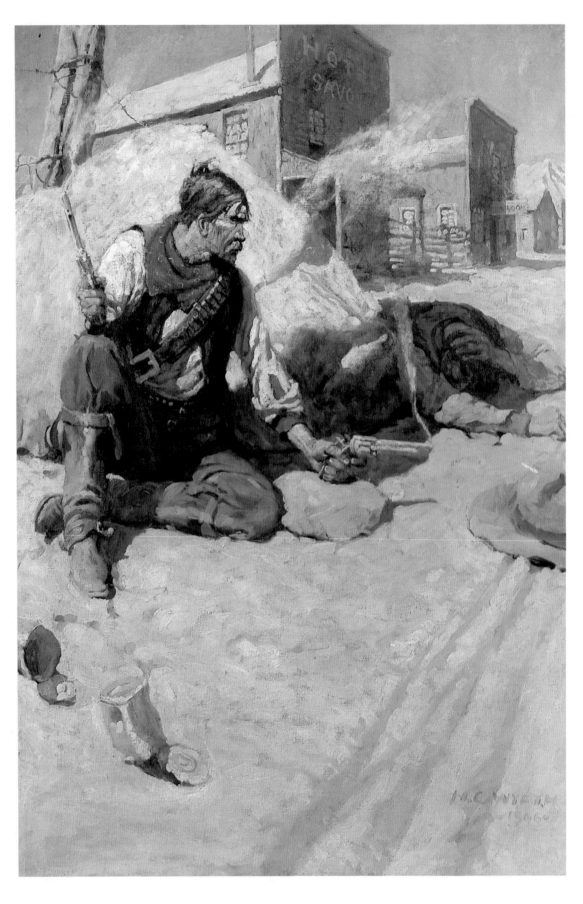

Above

SITTING UP CROSS-LEGGED WITH EACH HAND HOLDING A
GUN FROM WHICH CAME THIN WISPS OF SMOKE, 1906
'Bar 20 Range Yarns' by Clarence Edward Mulford
Outing Magazine, May 1906
Oil on canvas, 37 × 26 inches (95 × 66 cm)
Collection of First Interstate Bank of Arizona, N.A.,
Phoenix, AZ

Right

THE PROSPECTOR, 1906
'The Story of Montana' by C. P. Connolly
McClure's Magazine, September 1906
Oil on canvas, 47 × 29¾ inches (120 × 67 cm)
Collection of First Interstate Bank of Arizona, N.A.,
Phoenix, AZ

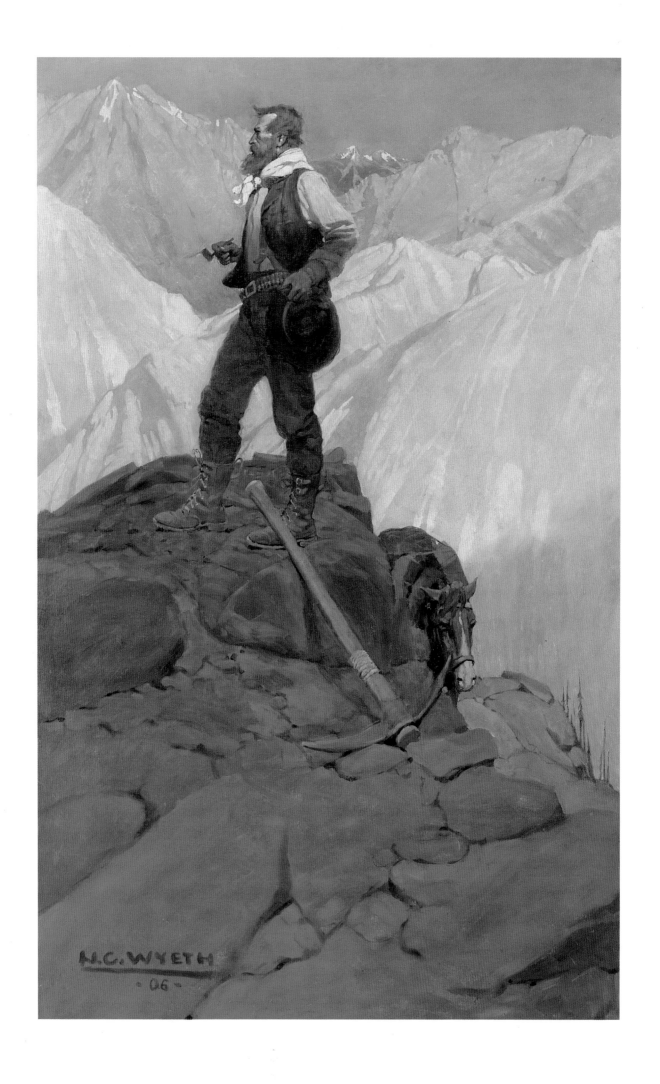

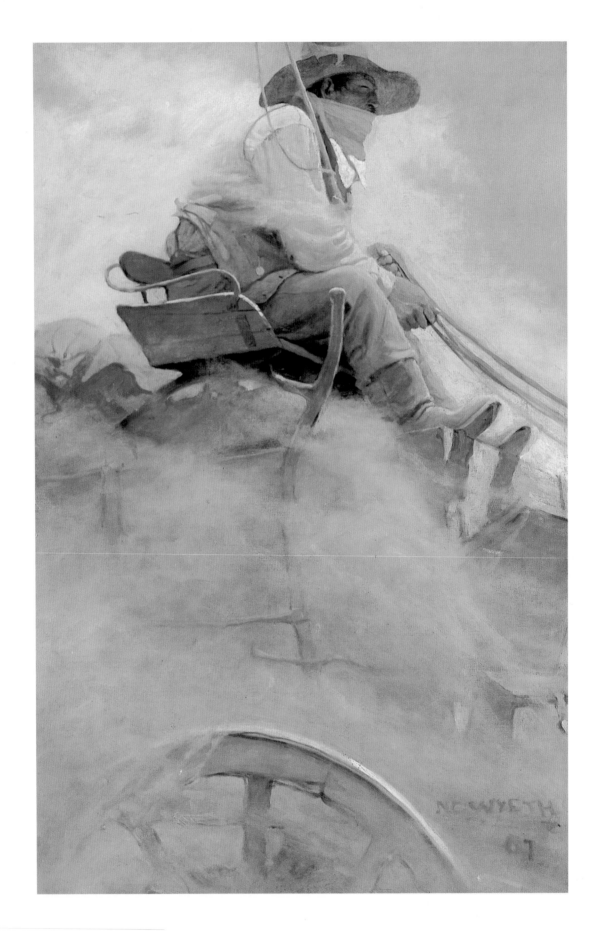

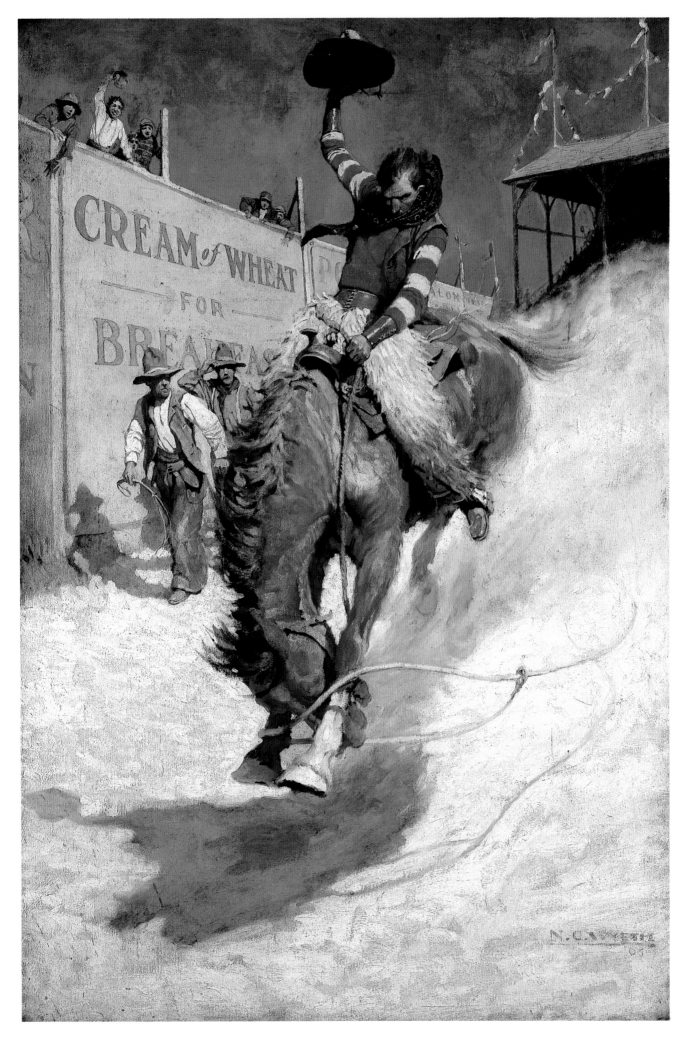

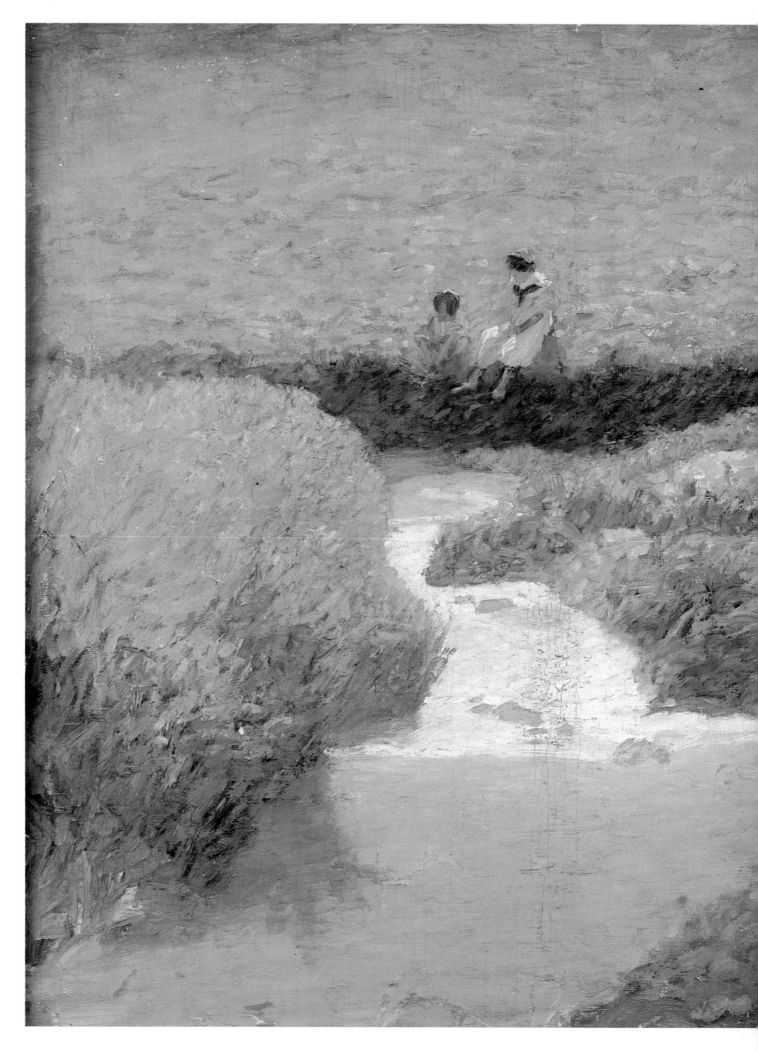

Summer Days, 1909
Oil on canvas, 16 × 20 inches (41 × 51 cm)
Collection of Mr and Mrs Andrew Wyeth
Photograph courtesy of the
Brandywine River Museum

17

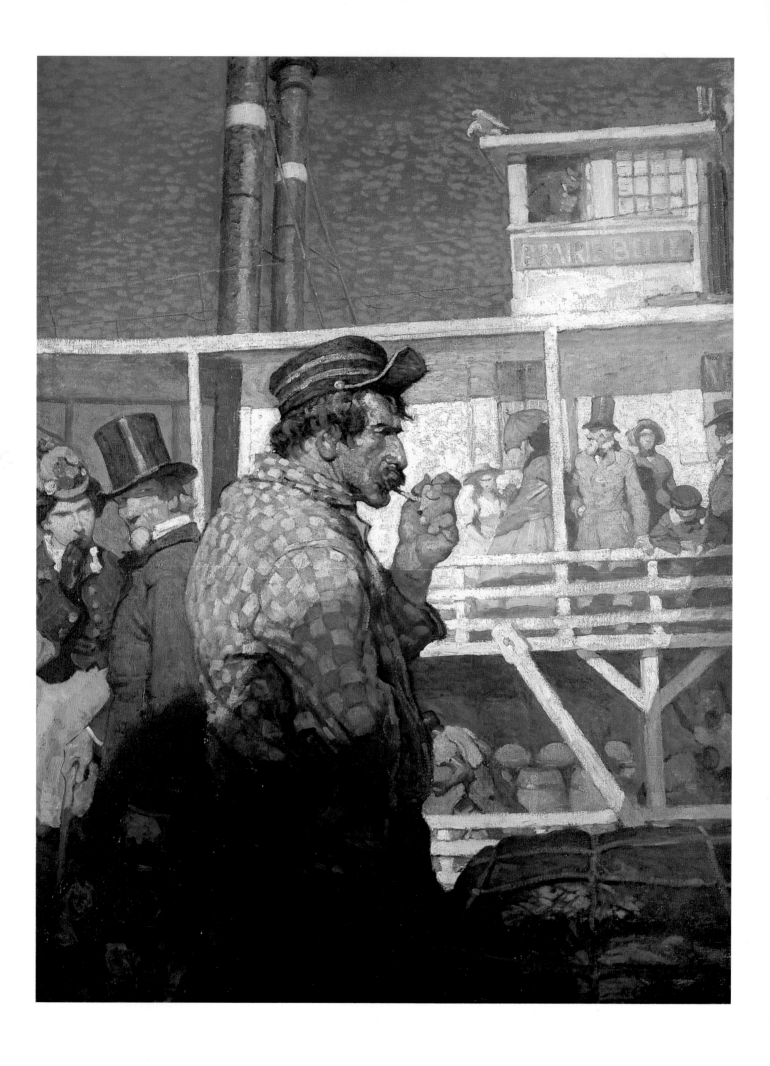

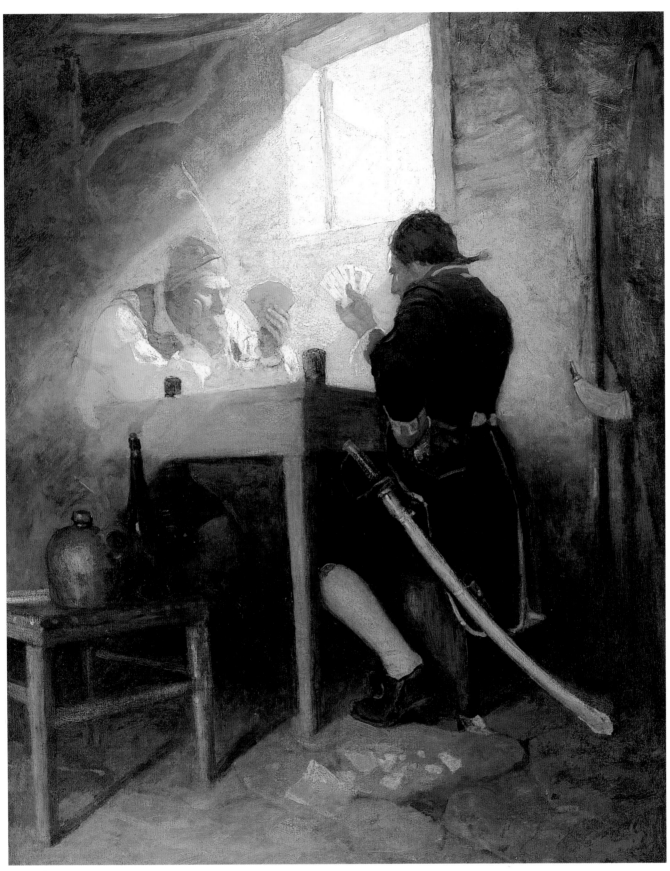

Left
JIM BLUDSOE, *c.*1906
The Pike County Ballads by John Hay
Houghton Mifflin, Boston, 1912
Oil on canvas, 32½ × 25½ inches (83 × 65 cm)
Collected by C. T. and Claire McLaughlin
Diamond M. Foundation Fine Art Collection, Lubbock,
TX
Photograph by Nicky Olson

Above
AT THE CARDS IN CLUNY'S CAGE, 1913
Kidnapped by Robert Louis Stevenson
Charles Scribner's Sons, 1913
Oil on canvas, 40 × 32 inches (102 × 82 cm)
Bequest of Mrs Russell G. Colt
Collection of the Brandywine River Museum,
Chadds Ford, PA
Photograph by Peter Ralston

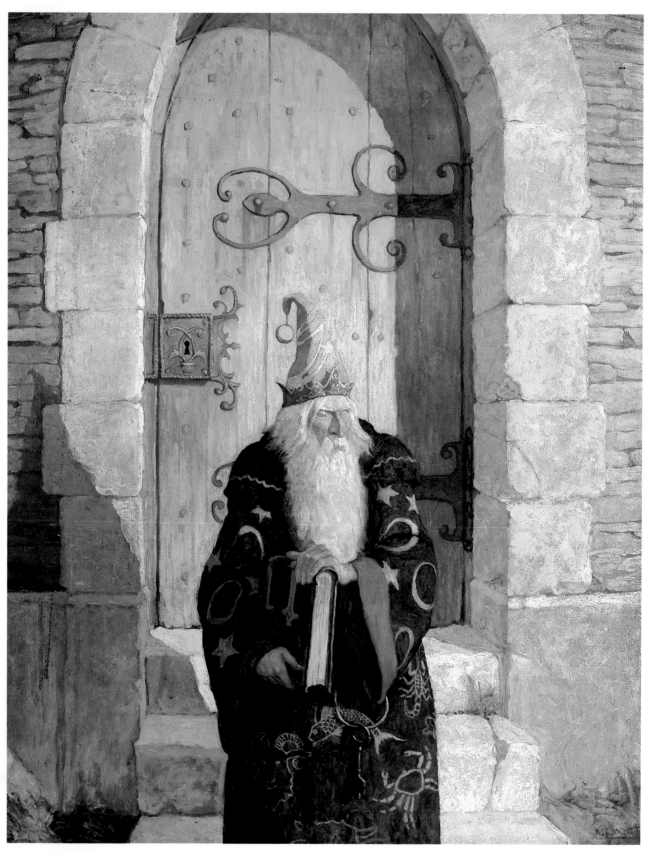

Above
THE ASTROLOGER (ON THE FOURTH DAY COMES THE
ASTROLOGER FROM HIS CRUMBLING OLD TOWER), 1916
The Mysterious Stranger by Mark Twain
Harper and Brothers, Publishers, 1916
Oil on canvas, 40 × 32 inches (102 × 82 cm)
Collected by C. T. and Claire McLaughlin
Diamond M. Foundation Fine Art Collection,
Lubbock, TX
Photograph by Nicky Olson

Right
SIR TRISTRAM AND LA BELLE ISOLDE IN THE GARDEN, 1917
The Boy's King Arthur edited by Sidney Lanier
Charles Scribner's Sons, 1917
Oil on canvas, 39¾ × 32 inches (102 × 82 cm)
Collection of the Brandywine River Museum,
Chadds Ford, PA
Photograph by Peter Ralston

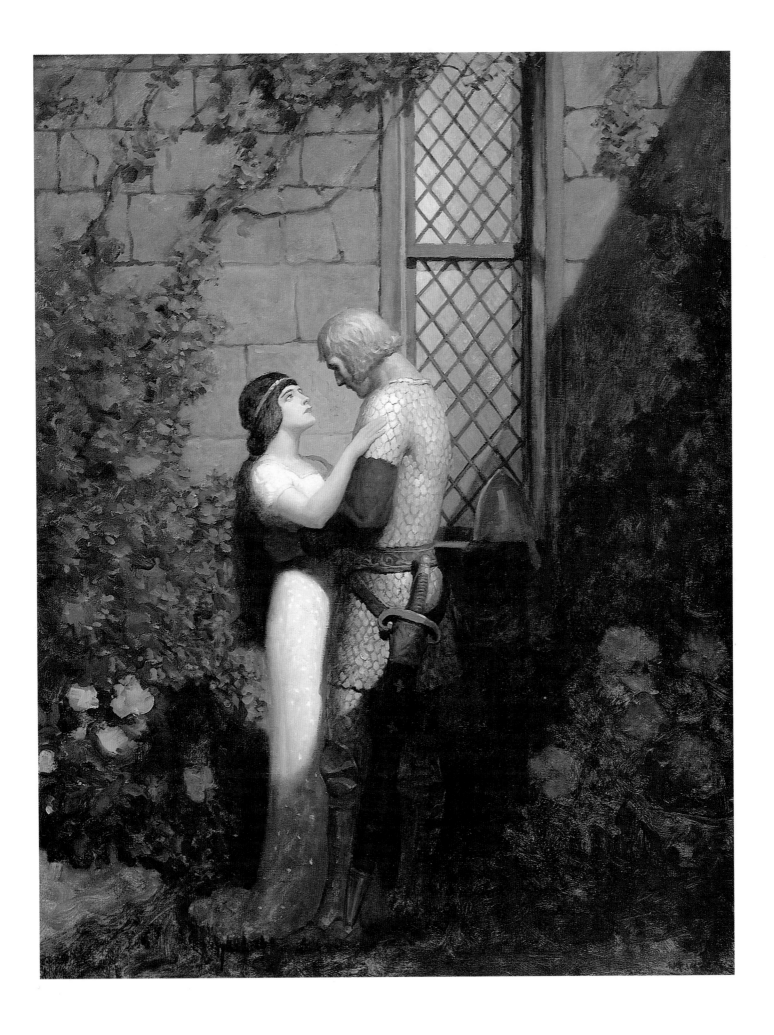

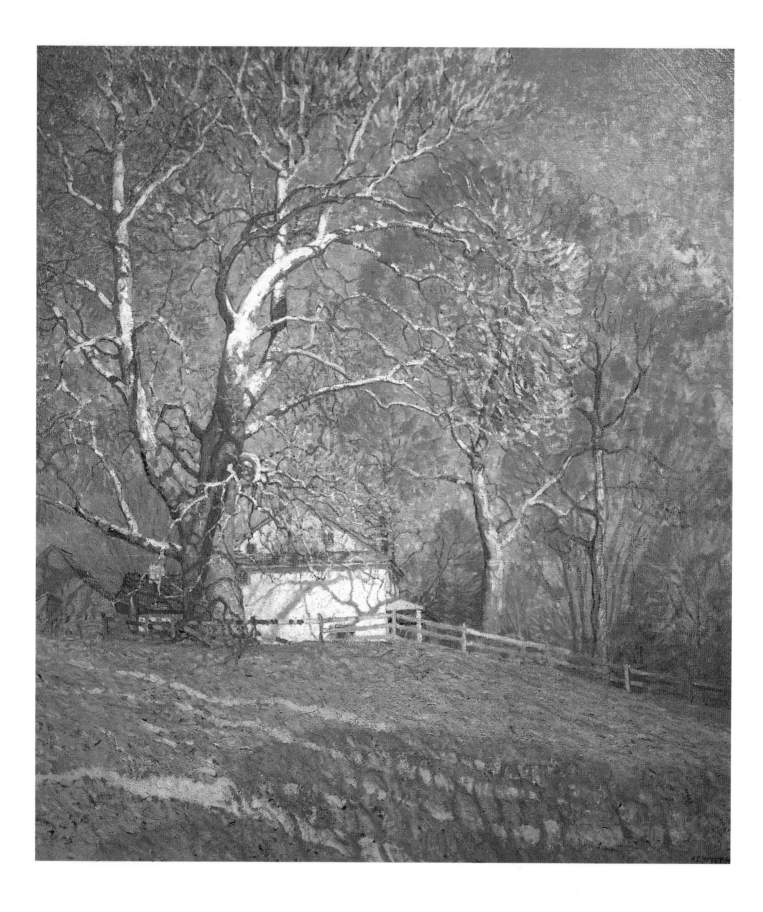

Right
I STOOD LIKE ONE THUNDERSTRUCK OR AS IF I HAD SEEN
AN APPARITION, 1920
Robinson Crusoe by Daniel Defoe
Cosmopolitan Book Corporation
Oil on canvas, 40 × 30 inches (102 × 77 cm)
Collection of the Wilmington Institute Library, DE
Photograph by Peter Ralston courtesy of the
Brandywine River Museum

Above
BUTTONWOOD FARM, 1920
Oil on canvas, 48½ × 42¾ inches (124 × 109 cm)
Courtesy of the Reading Public Museum and Art Gallery,
Reading, PA

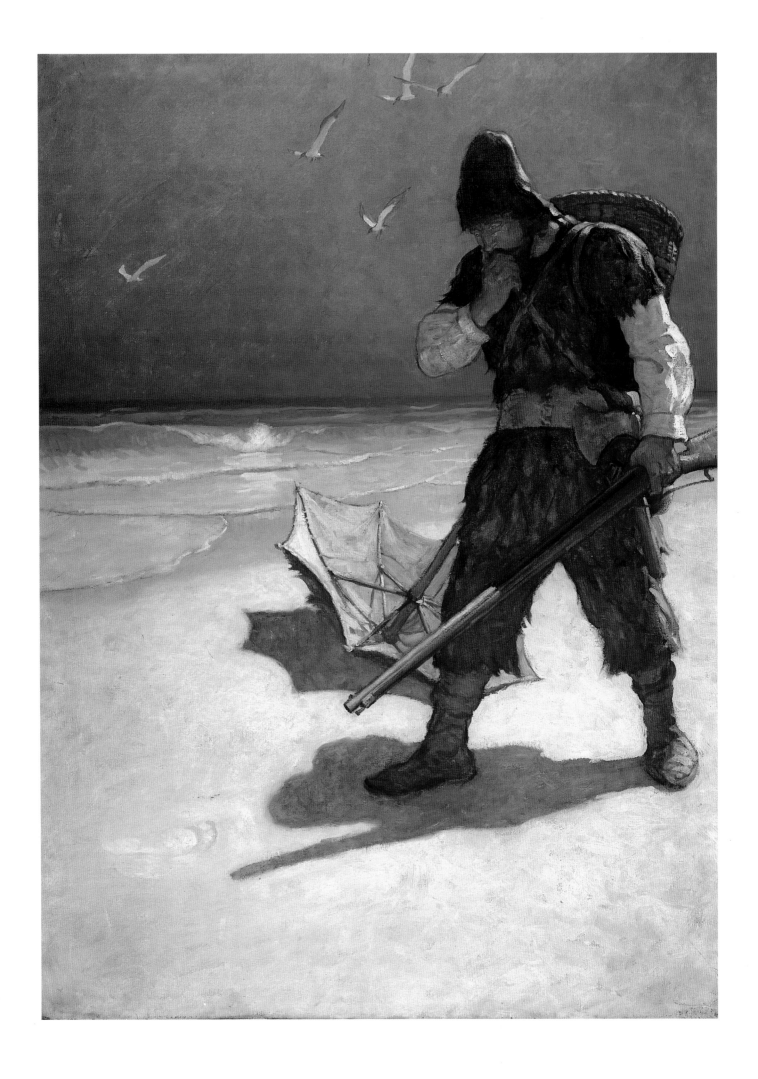

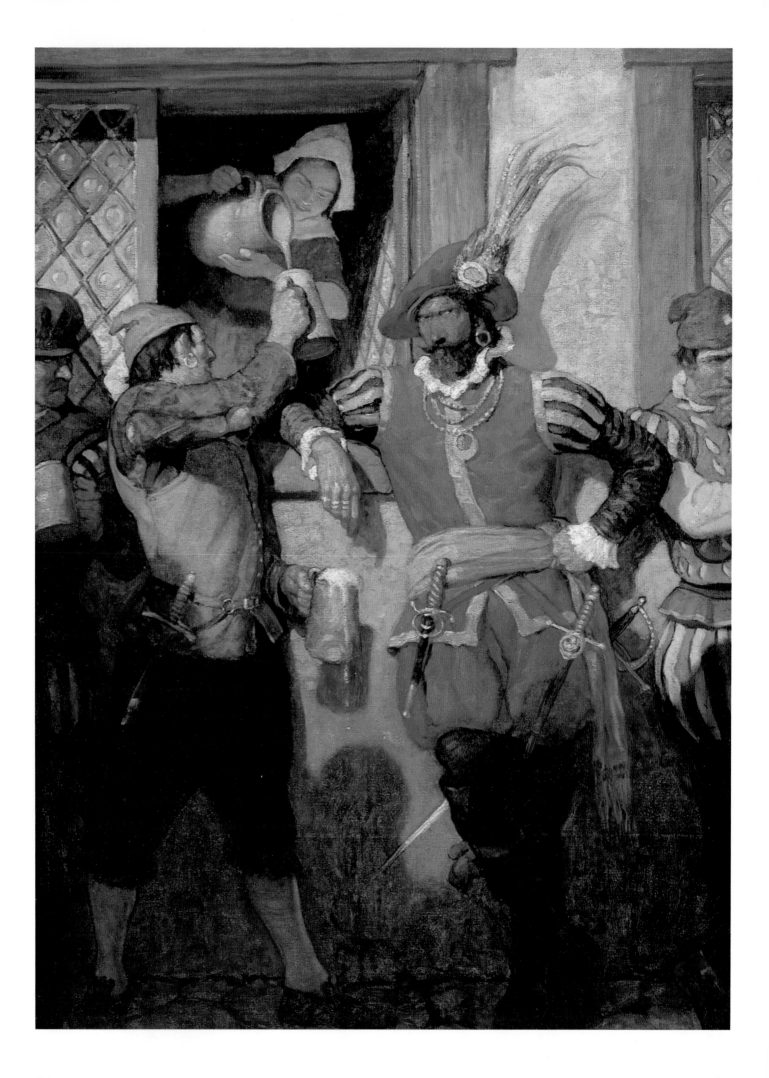

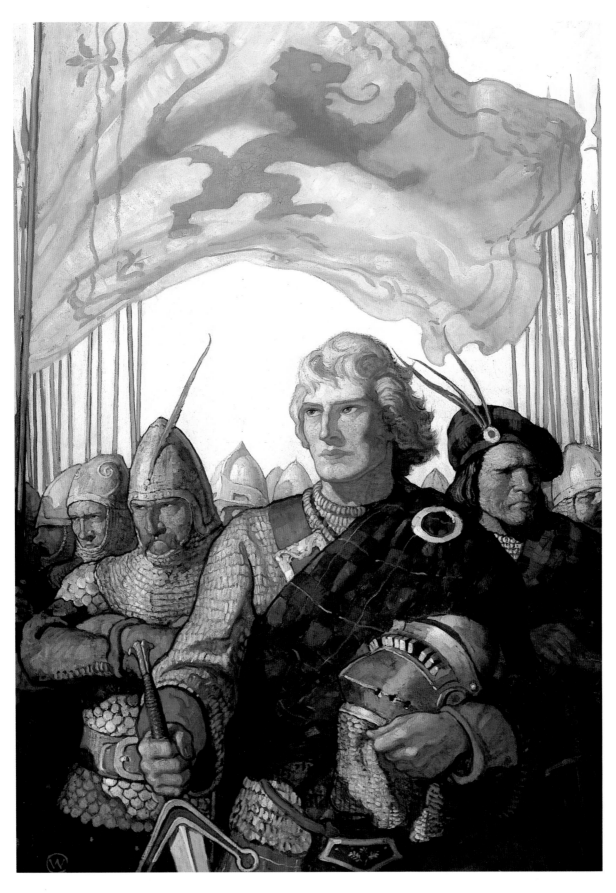

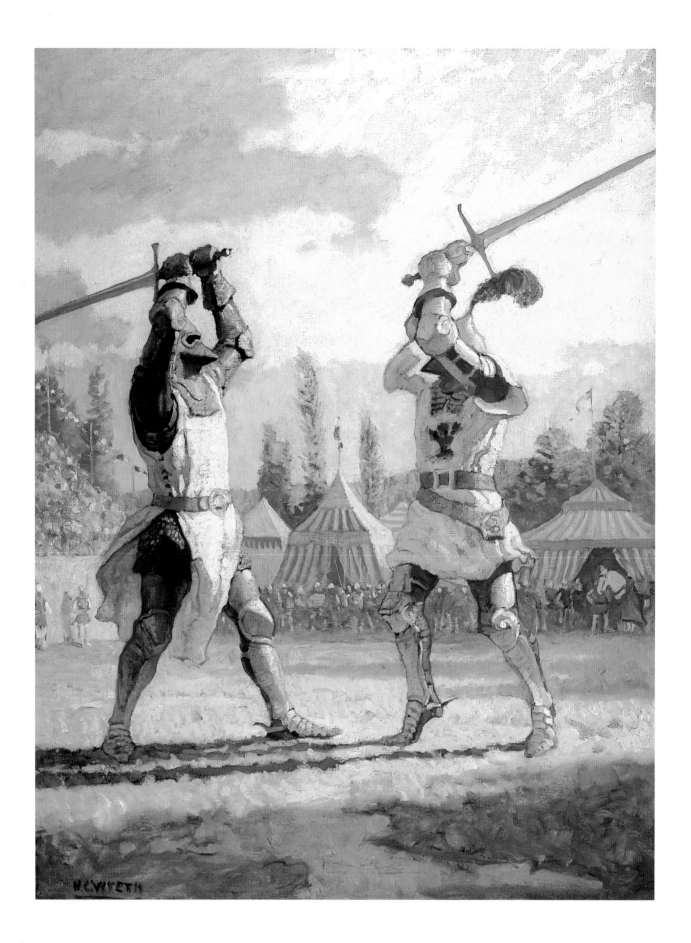

Above
SIR NIGEL SUSTAINS ENGLAND'S HONOR IN THE LISTS, 1922
The White Company by Sir Arthur Conan Doyle
Cosmopolitan Book Corporation, 1922
Oil on canvas, 40 × 30¼ inches (102 × 78 cm)
Courtesy of Millport Conservancy
Photograph by Peter Ralston

Right
THE GIANT, 1923
Oil on canvas, 72 × 60 inches (184 × 154 cm)
Courtesy of the Westtown School, Westtown, PA
Photograph courtesy of the Brandywine River Museum

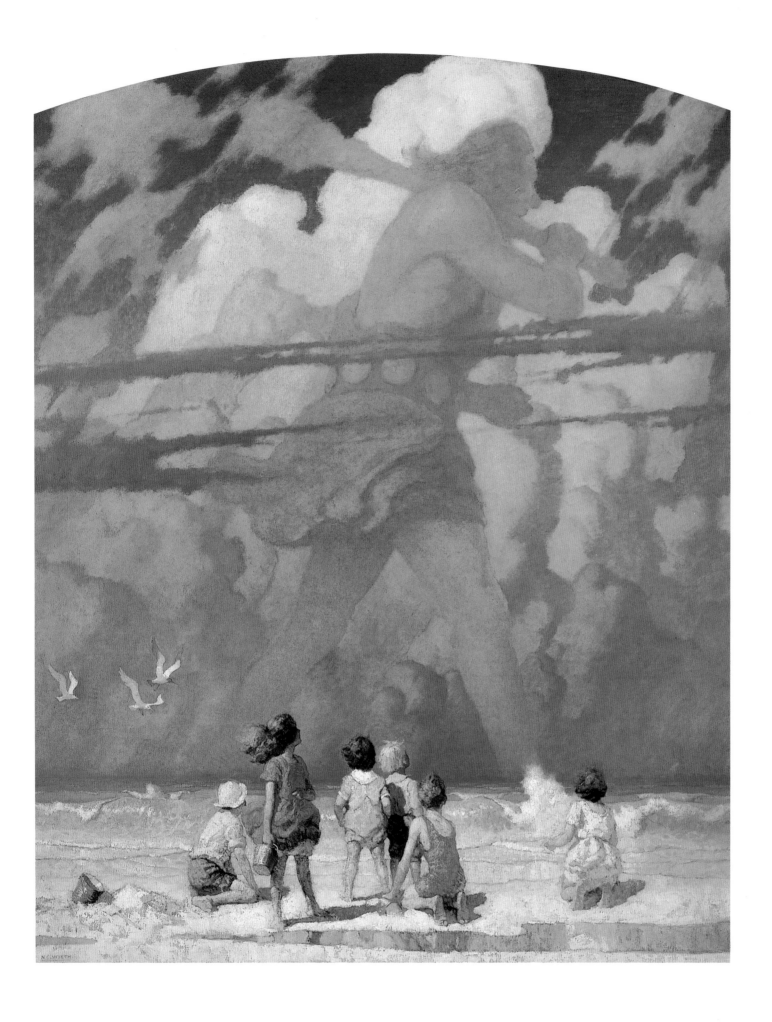

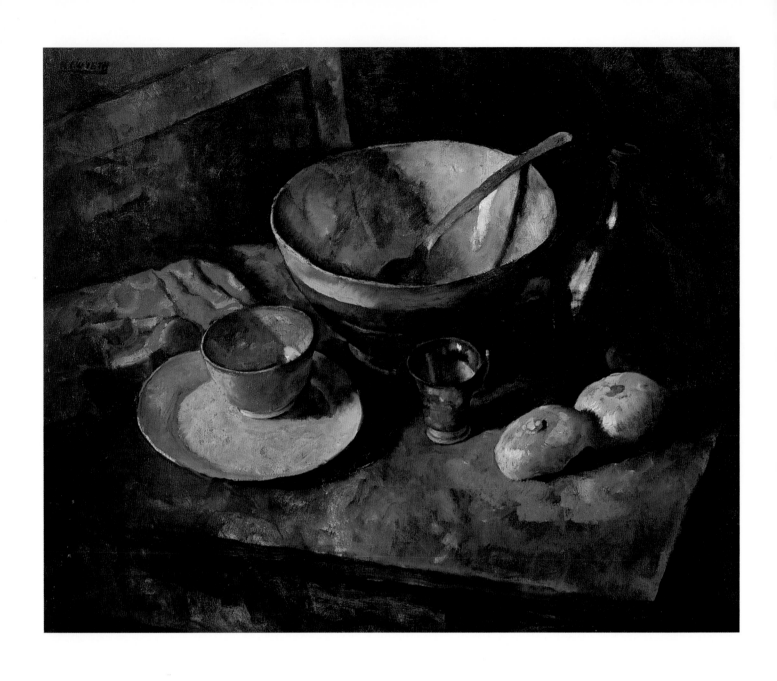

Above
STILL LIFE WITH ONIONS, *c.*1924
Oil on canvas, 32¼ × 47¼ inches (83 × 121 cm)
Given in memory of Clement R. Hoopes by his family and friends
Collection of the Brandywine River Museum, Chadds Ford, PA

Right
OLD KRIS, 1925
Cover, *Country Gentleman* December 1925
Oil on canvas, 34 × 30½ inches (87 × 78 cm)
© *1985 by A. B. McCoy*
Photograph courtesy of the Brandywine River Museum

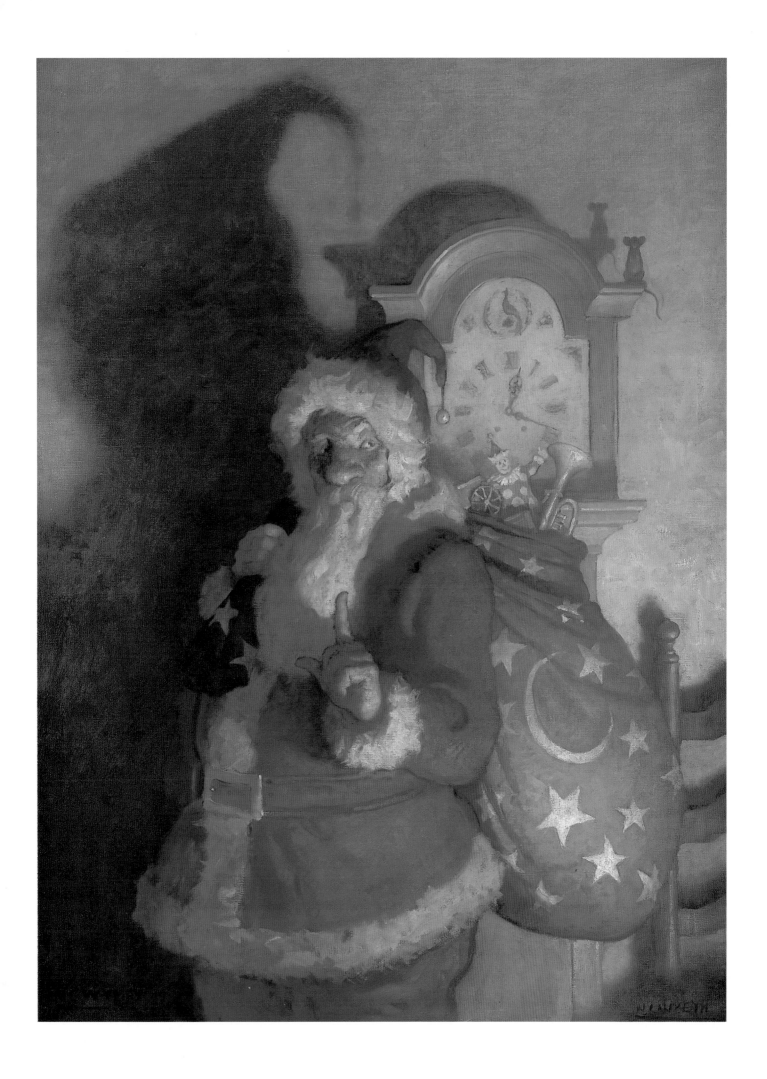

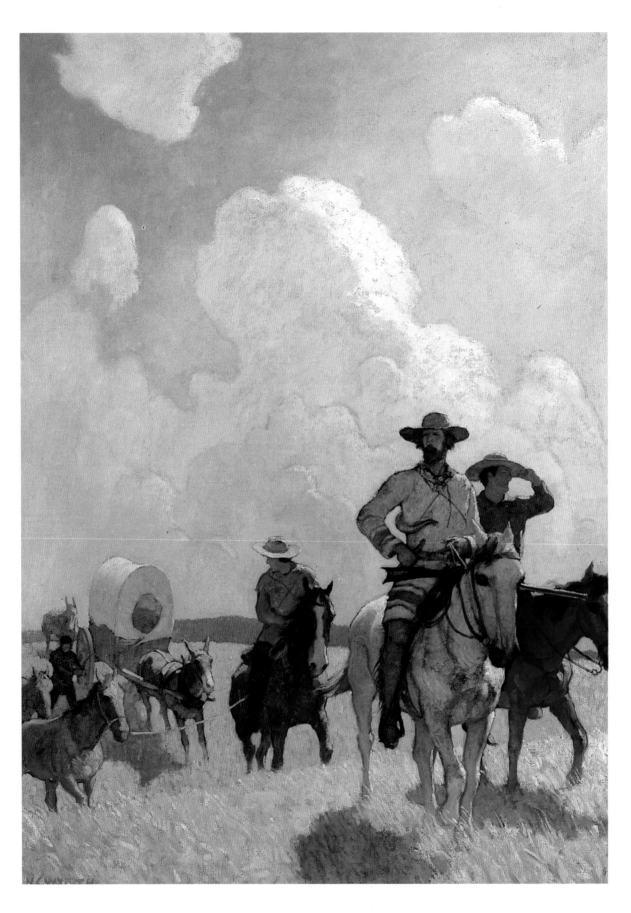

Above
THE PARKMAN OUTFIT – HENRY CHATILLON, GUIDE AND
HUNTER, *c.1925*
The Oregon Trail by Francis Parkman
Little, Brown and Company, 1925
Oil on canvas, 40½ × 29⅛ inches (104 × 75 cm)
Collection of First Interstate Bank of Arizona, N.A.,
Phoenix, AZ

Right
FRANCIS PARKMAN, *c.1925*
Frontispiece, *The Oregon Trail* by Francis Parkman
Little, Brown and Company, 1925
Oil on canvas, 40 × 28 inches (103 × 72 cm)
Courtesy of the National Cowboy Hall of Fame and
Western Heritage Center, Oklahoma City, OK

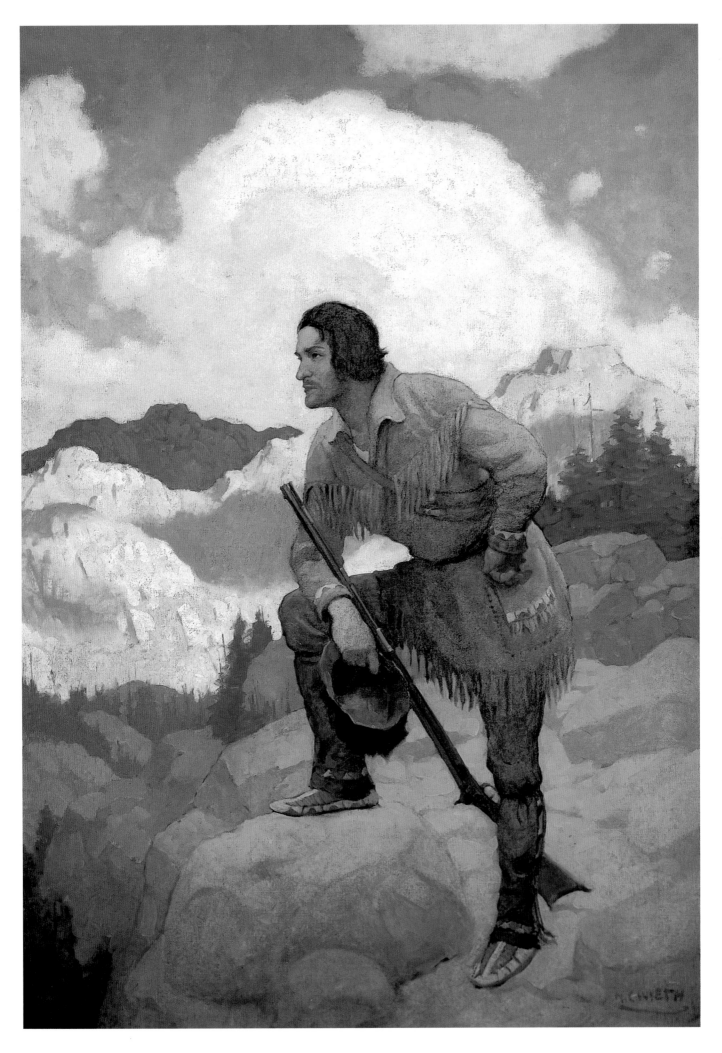

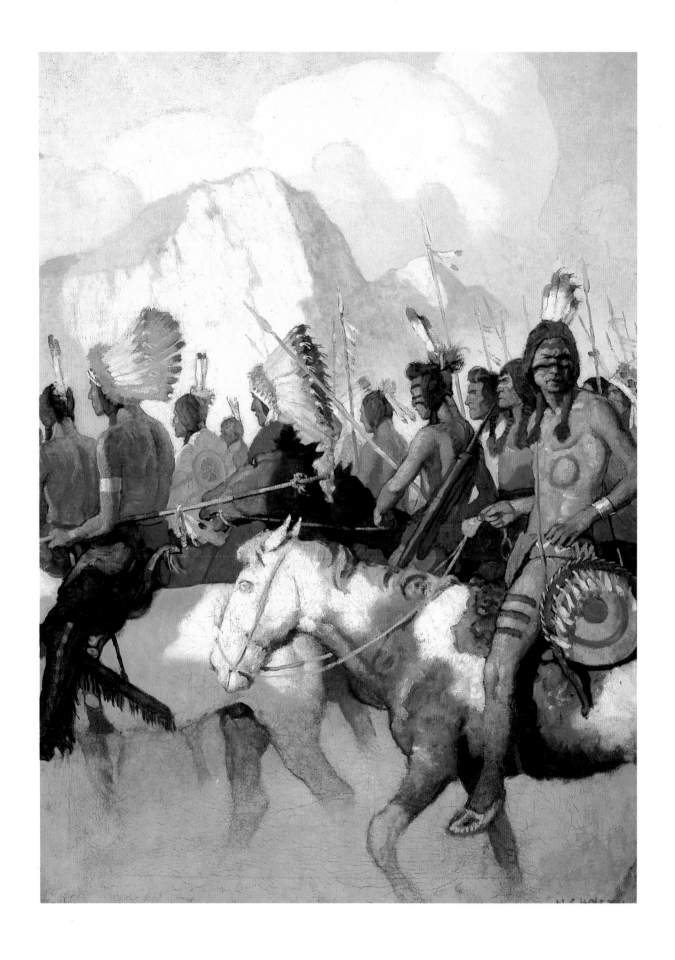

Above
AN INDIAN WAR PARTY, *c.*1925
The Oregon Trail by Francis Parkman
Little, Brown and Company, 1925
Oil on canvas, 38⅝ × 28 inches (99 × 72 cm)
Gene Autry Western Heritage Museum, Los Angeles, CA

Right
COWBOY WATERING HIS HORSE, *c.*1937
Oil on masonite, 36 × 24 inches (92 × 61 cm)
Museum of Texas Tech University, Lubbock, TX
Photograph by Nicky Olson

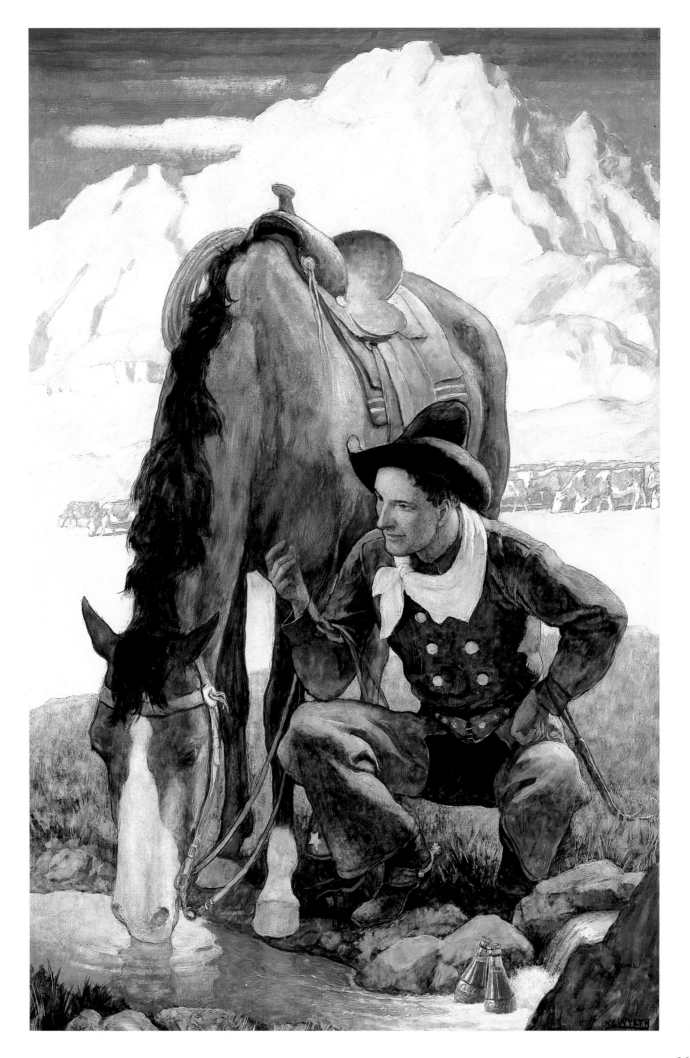

33

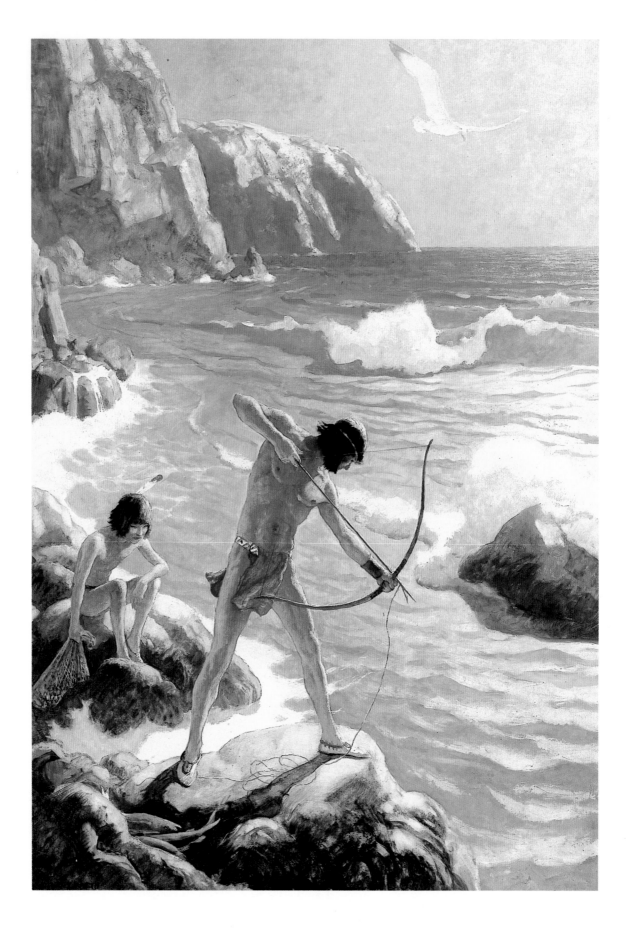

Above
THE FIRST MAINE FISHERMEN, 1937
Trending into Maine by Kenneth Roberts
Little, Brown and Company, 1938
Oil on panel, 35 × 25 inches (90 × 63.5 cm)
Photograph courtesy of the Brandywine Fantasy Gallery,
Chicago, IL

Right
COCA-COLA CALENDAR ILLUSTRATION, 1937
Courtesy of the Coca-Cola Company Archives,
Atlanta, GA

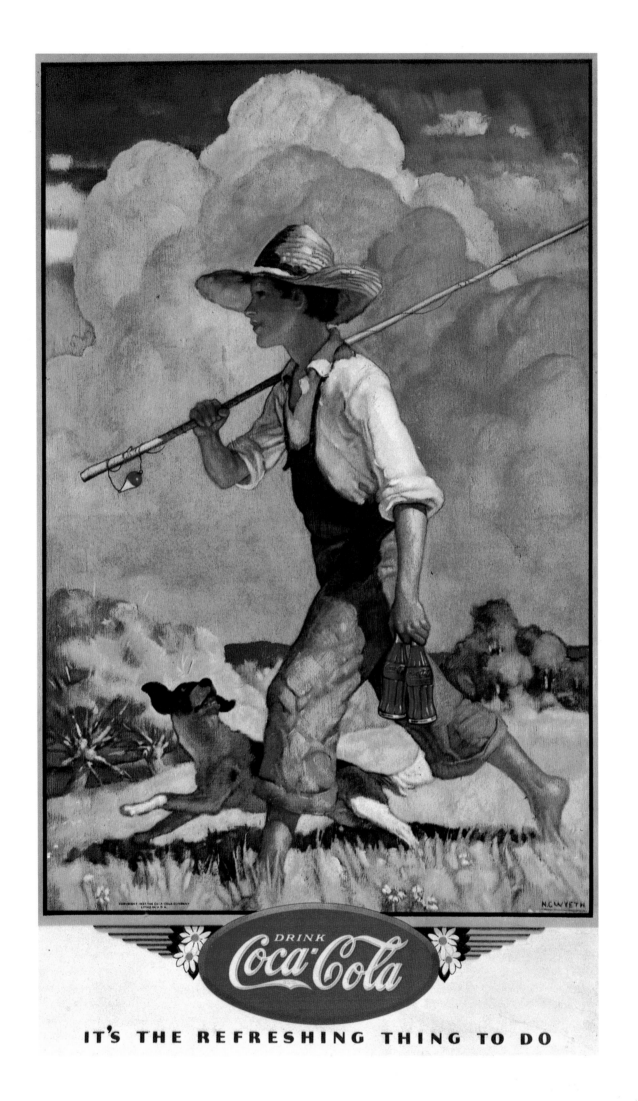

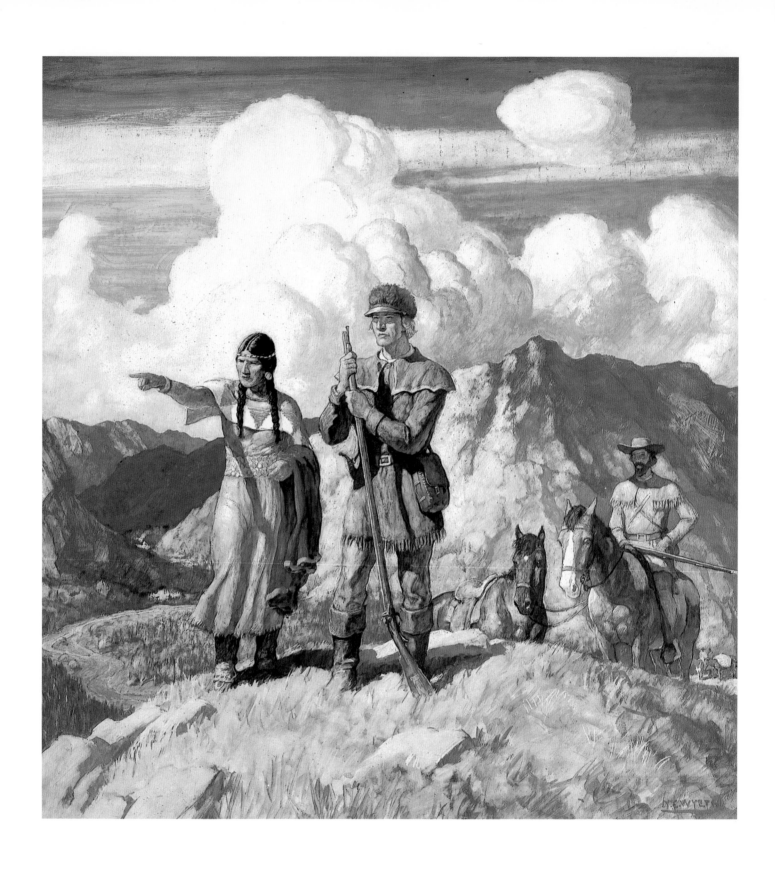

LEWIS AND CLARK, 1939
America in the Making, calendar published for John
Morrell & Company, Ottumwa, IA, 1940
Oil with some tempera on panel, 26½ × 14½ inches
(67 × 37 cm)
Gift of John Morrell & Company, 1940
From the University Art Collection, Iowa State University,
Ames, IA

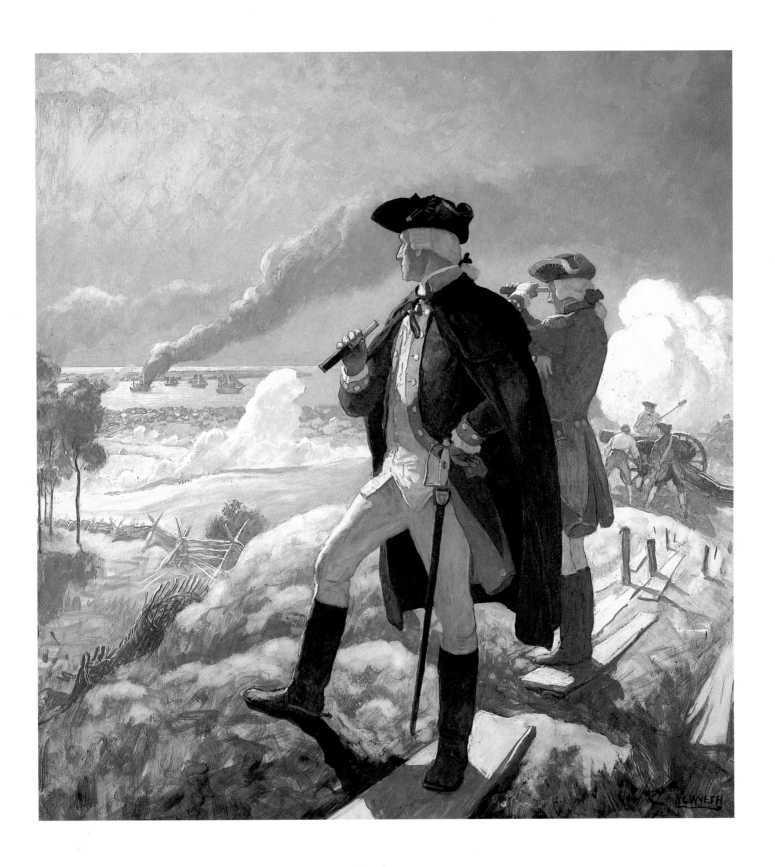

George Washington at Yorktown, 1940
America in the Making, calendar published for John
Morrell & Company, Ottumwa, IA, 1940
Oil with some areas of tempera on panel, 26¾ × 25 inches
(68 × 63.5 cm)
Gift of John Morrell & Company, 1940
From the University Art Collection, Iowa State University,
Ames, IA

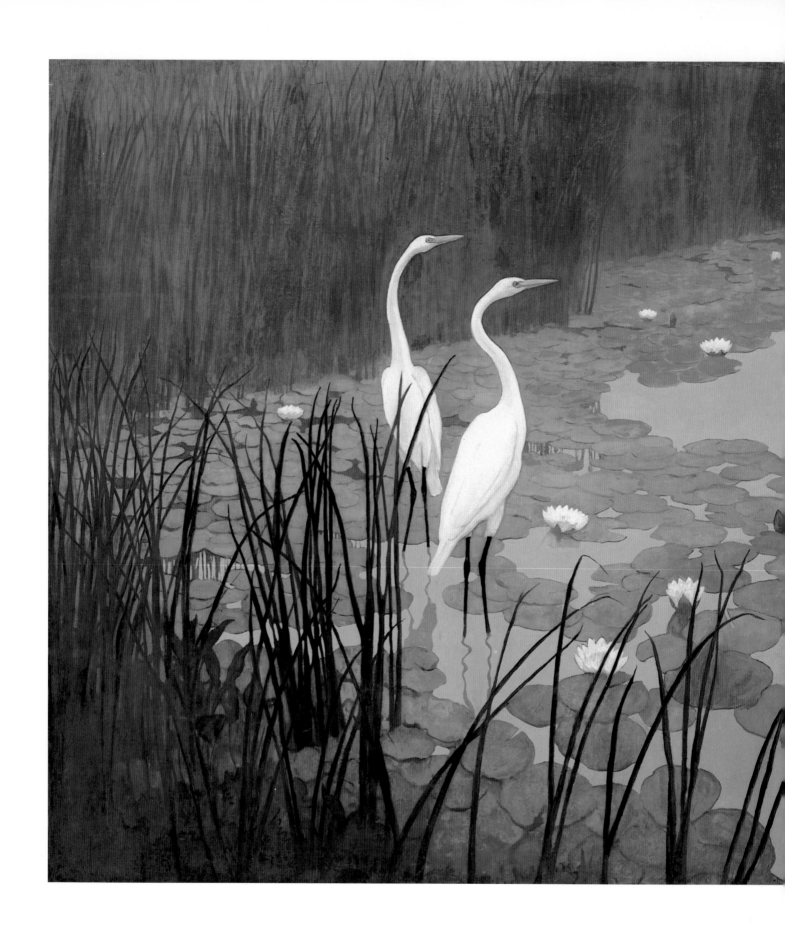

EGRETS IN SUMMER, 1940-45
Oil on canvas, 82⅞ × 159 inches (212 × 404 cm)
From the Collection of the Metropolitan Life Insurance
Company, New York NY
Photograph © Malcolm Varon, New York, NY

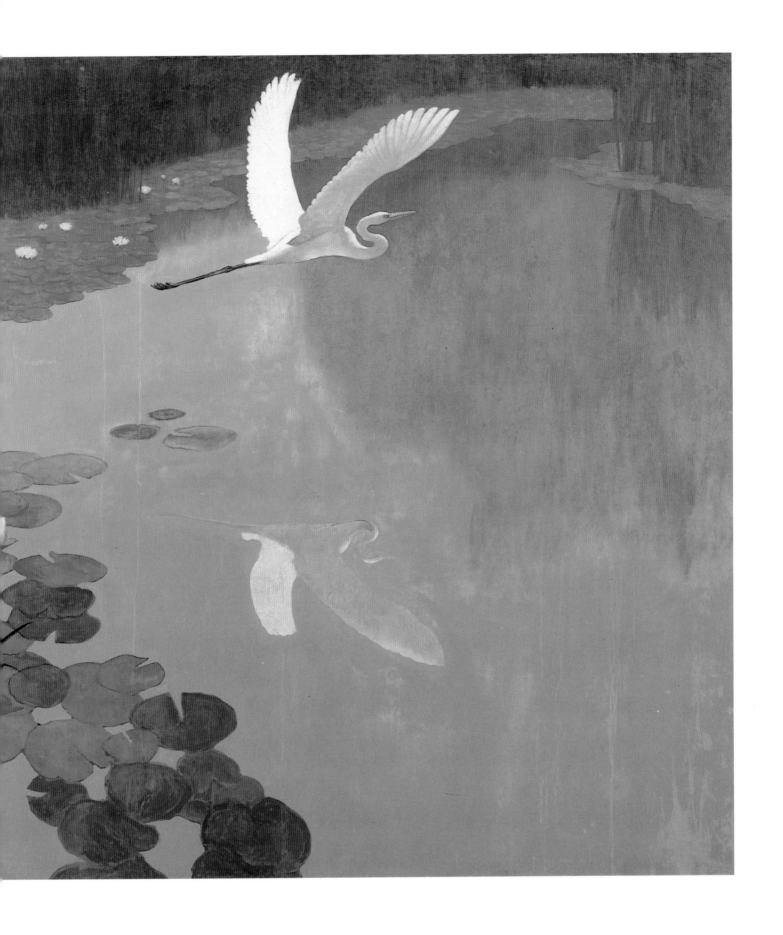

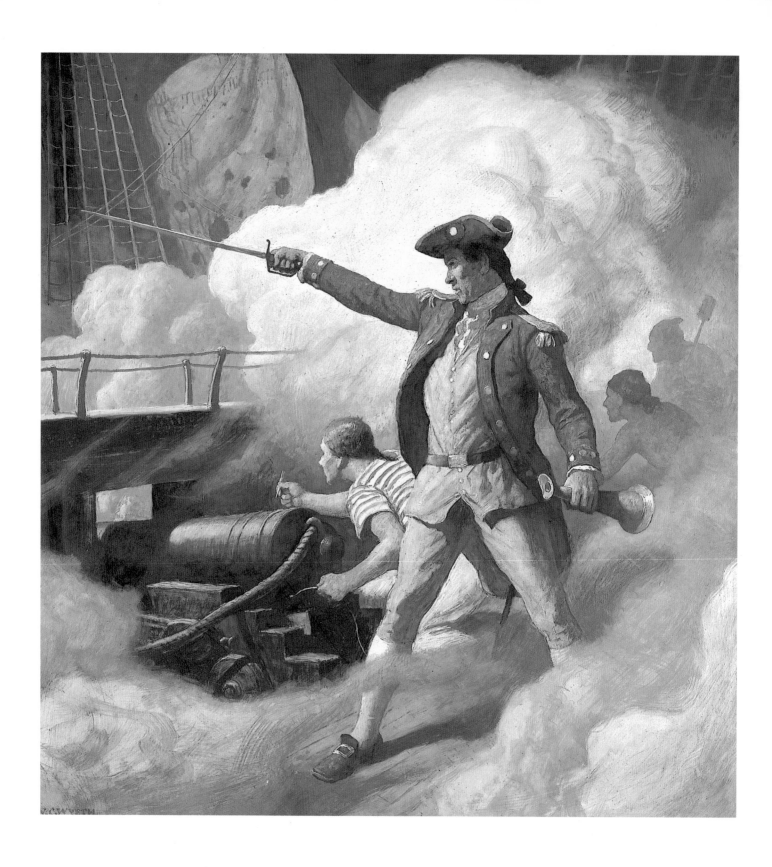

Above
CAPTAIN JOHN PAUL JONES, 1940
America in the Making, calendar published for
John Morrell & Company, Ottumwa, IA, 1940
Oil with some areas of tempera on panel, 27 × 25 inches
(69 × 63.5 cm)
Gift of John Morrell & Company, 1940
*From the University Art Collection, Iowa State University,
Ames, IA*

Right
SHE MAKES A GRAND LIGHT (THE BURNING OF THE
BOUNTY), 1940
The Bounty Trilogy by Charles Nordoff and James
Norman Hall
Little, Brown and Company
Oil on canvas, 34 × 25 inches (86 × 63.5 cm)
Courtesy of the Free Library of Philadelphia, PA
Photograph by Nate Clark

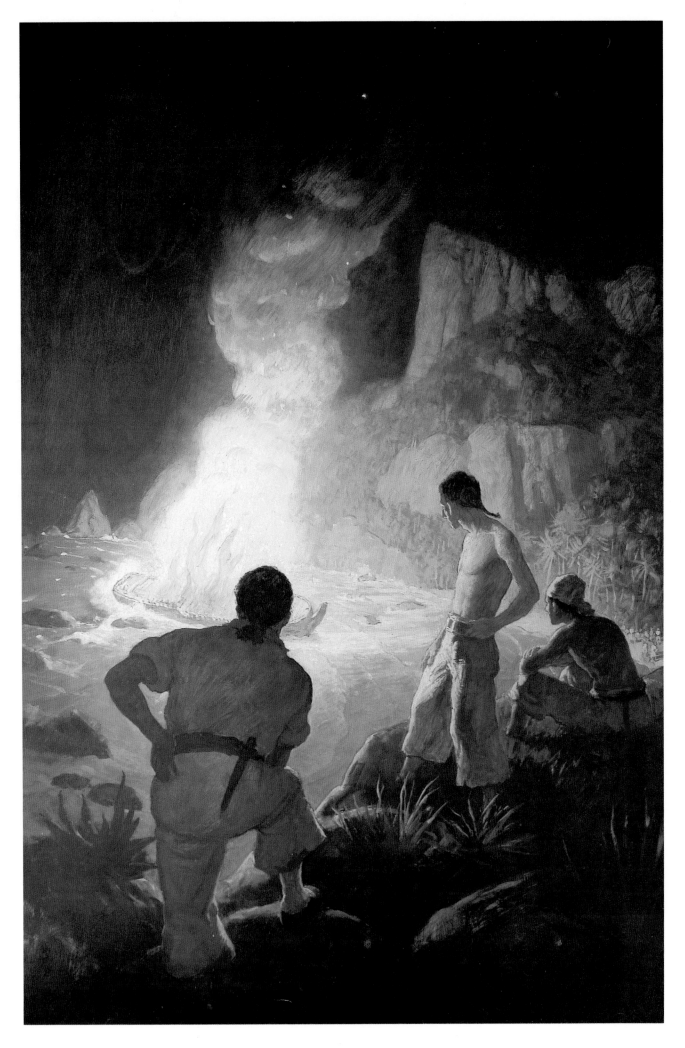

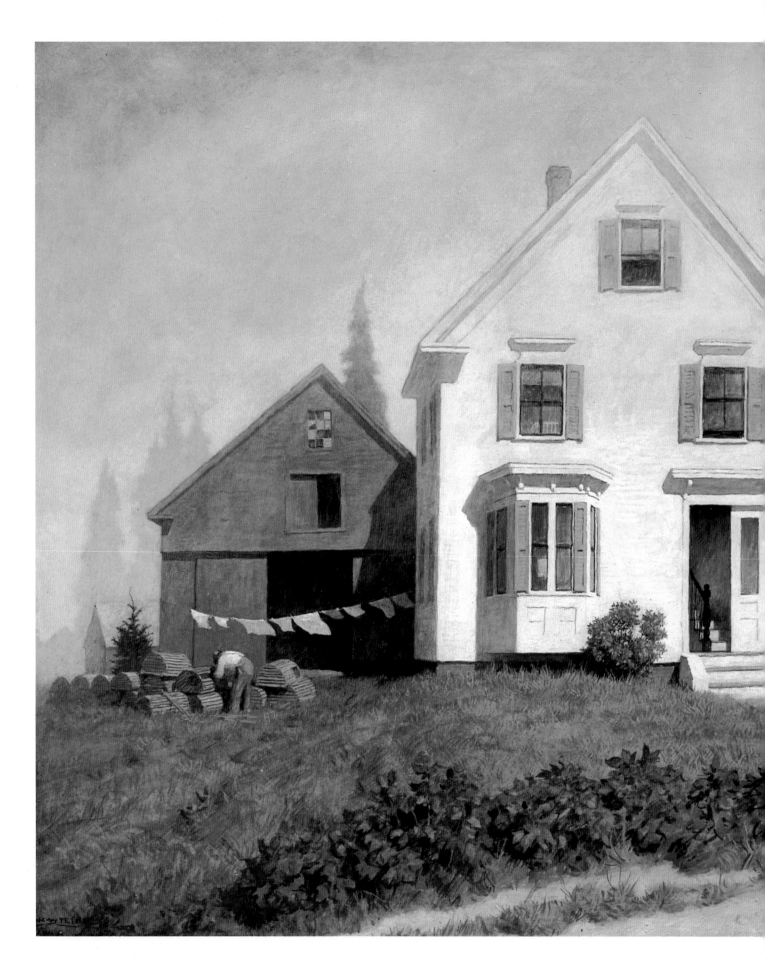

MRS CUSHMAN'S HOUSE, 1942
Tempera, 21½ × 37⅜ inches (55 × 95 cm)
Harriet Russell Stanley Fund
Courtesy of the New Britain Museum of American Art,
New Britain, CT

LAST OF THE CHESTNUTS, 1917
Oil on canvas, 37¼ × 49¼ inches (95 × 125 cm)
Collected by C. T. and Claire McLaughlin
Diamond M. Foundation Fine Art Collection, Lubbock,
TX
Photograph by Nicky Olson